THE BEGINNING OF THE WORLD

EDWARD BURNE-JONES.

PALLAS ATHENE

THE DESIGNS IN THIS BOOK WERE made for an illustrated edition of Mr. Mackail's "Biblia Innocentium," which was to have been produced by the Kelmscott Press and to have contained upwards of two hundred pictures. Many of these were begun, but none quite finished. The twenty-five designs here given were so far carried out that, with the help of Mr. Catterson Smith, it has been possible to complete and reproduce them. It was he who, under my husband's own eye, translated almost all the designs for the Kelmscott Chaucer from pencil into ink before they were engraved, and in so doing he learnt most intimately the manner and meaning of the artist. Accordingly, the conventions agreed upon for certain parts of the Chaucer drawings—as in sky, trees, and flowers—have been used here, and the colour tradition of black and white then taught has been followed. Where the pictures were finished, they have been exactly reproduced, and where, as in some parts, little more than a suggestion was given, the skill and sympathy of the pupil have understood it and made it visible to others. Any resulting incompletion of form and detail has been accepted as inevitable, but the spirit of the whole is rendered with extraordinary fidelity.

GEORGIANA BURNE-JONES.

3

IN THE BEGINNING GOD CREATED THE HEAVEN AND THE EARTH.

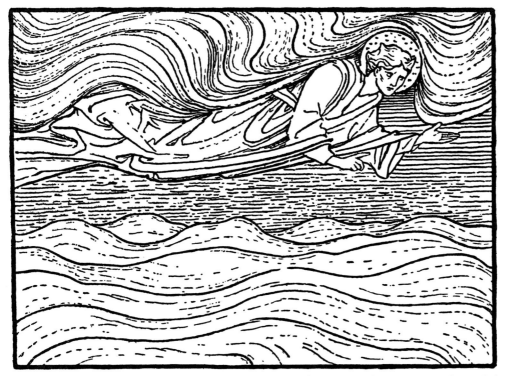

AND THE EARTH was without form, and void, and darkness was upon the face of the deep ; and the Spirit of God moved upon the face of the waters. And God said : Let there be light : and there was light ; and God saw the light, that it was good.

AND GOD DIVIDED the light from the darkness ; and God called the light Day, and the darkness he called Night.

AND GOD SAID : Let there be lights in the firmament of the heaven to divide the day from the night, and let them be for signs, and for seasons, and for days, and for years ; and let them be for lights in the firmament of the heaven to give light upon the earth : and it was so. And God made two great lights, the greater light to rule

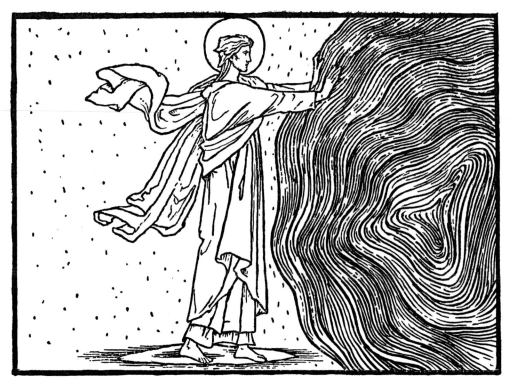

the day, and the lesser light to rule the night; he made the stars also; and God set them in the firmament of the heaven to give light upon the earth, and to rule over the day and over the night, and to divide the light from the darkness; and God saw that it was good.

AND GOD SAID: Let there be a firmament in the midst of the waters, and let it divide the waters from the waters: and God made the firmament, and divided the waters which were under the firmament from the waters which were above the firmament; and it was so; and God called the firmament Heaven. And God said: Let the waters under the heaven be gathered together unto one place, and let the dry land appear: and it was so; and God called the dry land Earth, and the gathering together of the waters called he Seas; and God saw that it was good.

6

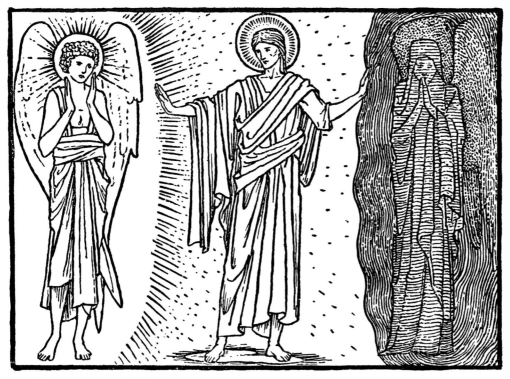

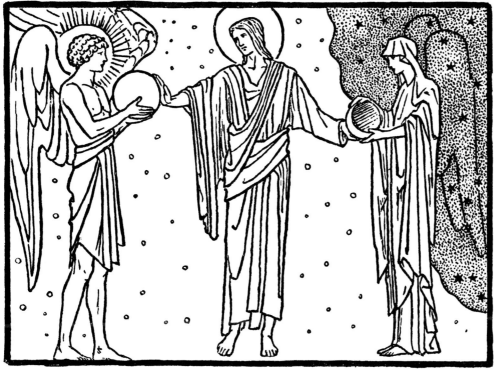

7

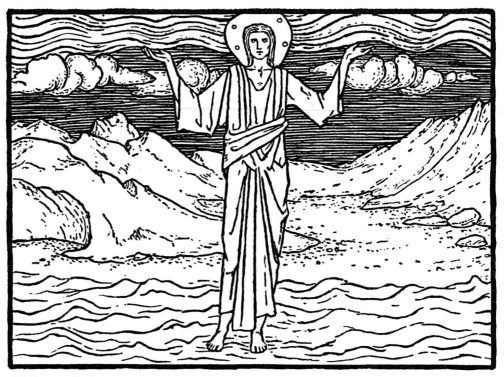

AND GOD SAID: Let the earth bring forth grass, the herb yielding seed and the fruit-tree yielding fruit after his kind, whose seed is in itself, upon the earth : and it was so ; and the earth brought forth grass, and herb yielding seed after his kind, and the tree yielding fruit, whose seed was in itself, after his kind ; and God saw that it was good. AND GOD SAID: Let the waters bring forth abundantly the moving creature that hath life, and fowl that may fly above the earth in the open firmament of heaven : and God created great whales, and every living creature that moveth, which the waters brought forth abundantly after their kind, and every winged fowl after his kind ; and God saw that it was good, and God blessed them, saying : Be fruitful, and multiply, and fill the waters in the seas, and let fowl multiply in the earth. AND GOD SAID: Let the earth bring forth the living

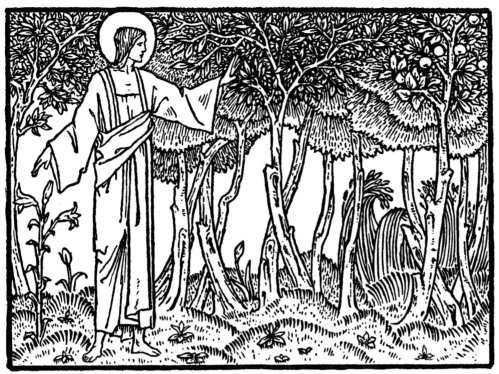

creature after his kind, cattle and creeping thing and beast
of the earth after his kind : and it was so; and God made
the beast of the earth after his kind, and cattle after their
kind, and every thing that creepeth upon the earth after
his kind ; and God saw that it was good. These are the
generations of the heavens and of the earth when they
were created, in the day that the Lord God made the earth
and the heavens, and every plant of the field before it was
in the earth, and every herb of the field before it grew.
AND GOD SAID : Let us make Man in our image
after our likeness ; and let them have dominion over the
fish of the sea and over the fowl of the air, and over the
cattle, and over all the earth, and over every creeping thing
that creepeth upon the earth : and the Lord God formed
man of the dust of the ground, and breathed into his
nostrils the breath of life, and man became a living soul.

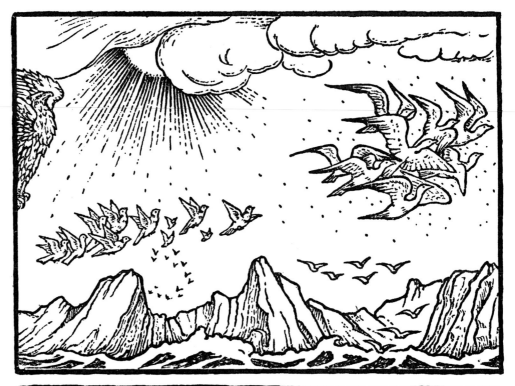

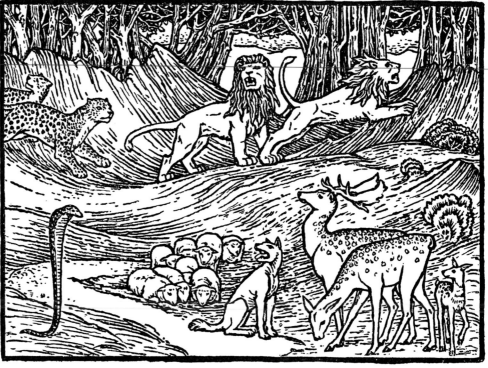

10

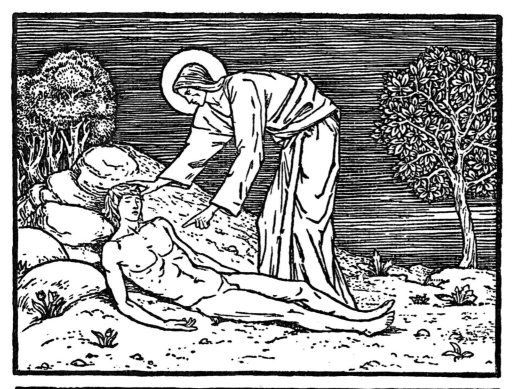

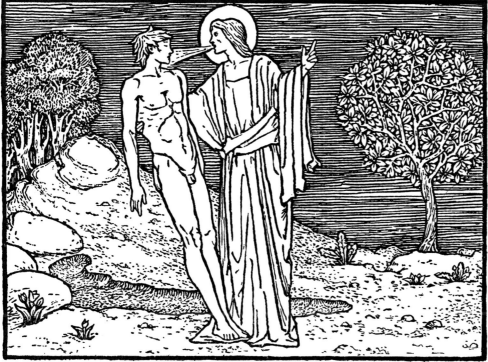

11

THUS THE HEAVENS AND THE EARTH were finished, and all the host of them; and on the seventh day God ended his work which he had made, and he rested on the seventh day from all his work which he had made; and God saw everything that he had made, and behold, it was very good.

AND THE LORD GOD SAID: It is not good that the man should be alone; I will make him a help meet for him: and the Lord God caused a deep sleep to fall upon Adam, and he slept; and he took one of his ribs and closed up the flesh instead thereof, and the rib which the Lord God had taken from man made he a woman. So God created man in his own image, in the image of God created he him; male and female created he them.

AND GOD BLESSED THEM, and God said unto them: Be fruitful, and multiply, and replenish the earth and subdue it, and have dominion over the fish of the sea and over the fowl of the air and over every living thing that moveth upon the earth. And God said: Behold, I have given you every herb bearing seed which is upon the face of all the earth, and every tree in the which is the fruit of a tree yielding seed; to you it shall be for meat; and to every beast of the earth, and to every fowl of the air, and to every thing that creepeth upon the earth wherein there is life, I have given every green herb for meat. And out of the ground the Lord God formed every beast of the field and every fowl of the air, and brought them unto Adam to see what he would call them; and whatsoever Adam called every living creature, that was the name thereof; and Adam gave names to all cattle and to the fowl of the air and to every beast of the field.

AND THE LORD GOD planted a garden eastward in Eden, and there he put the man whom he had formed.

12

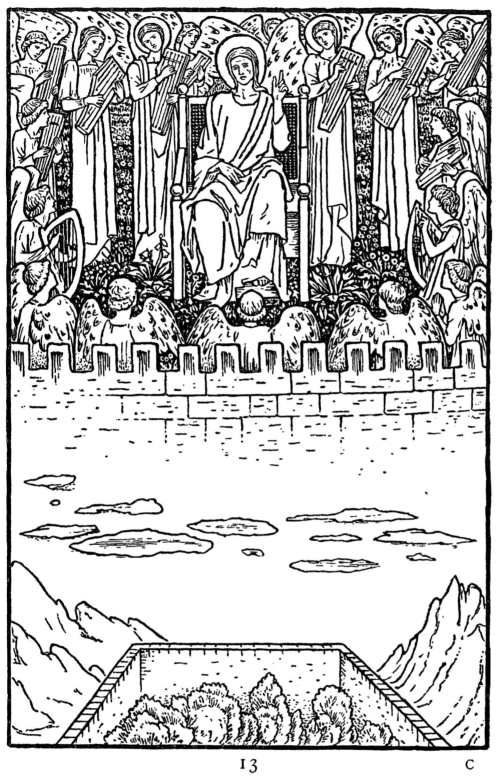

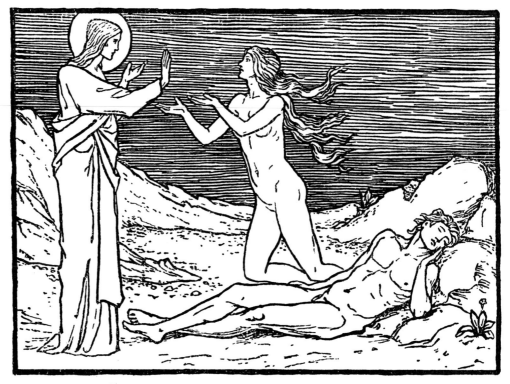

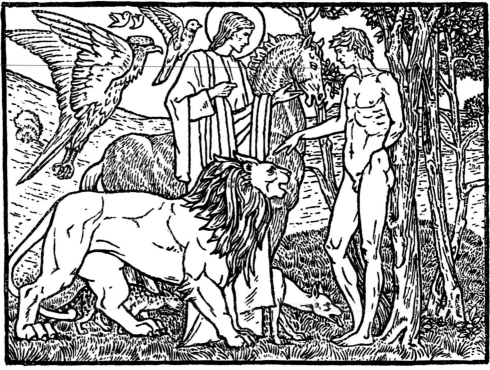

14

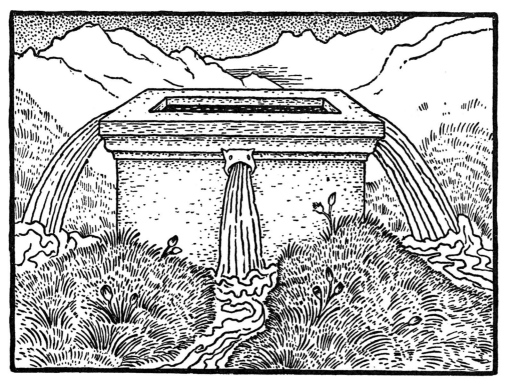

AND A RIVER WENT out of Eden to water the garden, and from thence it was parted and became into four heads. The name of the first is Pison: that is it which compasseth the whole land of Havilah where there is gold, and the gold of that land is good; there is bdellium and the onyx stone. And the name of the second river is Gihon: the same is it that compasseth the whole land of Ethiopia. And the name of the third river is Hiddekel: that is it which goeth toward the east of Assyria. And the fourth river is Euphrates.

AND OUT OF THE GROUND made the Lord God to grow every tree that is pleasant to the sight and good for food; the Tree of Life also in the midst of the garden, and the Tree of Knowledge of Good and Evil. AND THE LORD GOD took the man and put him into the garden of Eden to dress it and to keep it; and the

15

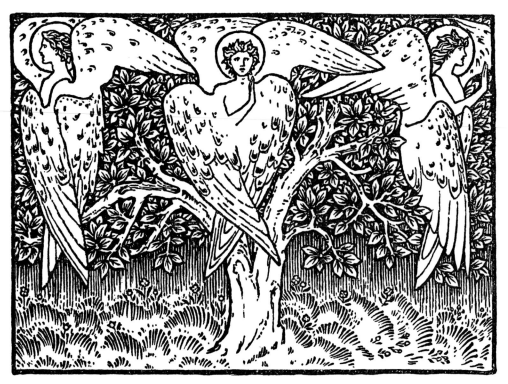

Lord God commanded the man, saying : Of every tree of the garden thou mayest freely eat, but of the Tree of the Knowledge of Good and Evil thou shalt not eat of it ; for in the day that thou eatest thereof thou shalt surely die. And they were both naked. the man and his wife, and were not ashamed.

NOW THE SERPENT was more subtle than any beast of the field which the Lord God had made ; and he said unto the woman: Yea, hath God said ye shall not eat of every tree of the garden ? and the woman said unto the serpent: We may eat of the fruit of the trees of the garden ; but of the fruit of the tree which is in the midst of the garden God hath said : Ye shall not eat of it, neither shall ye touch it, lest ye die. And the serpent said unto the woman : Ye shall not surely die ; for God doth know that in the day ye eat thereof then your eyes shall be opened

16

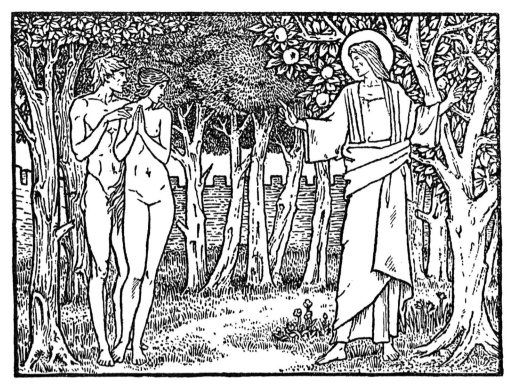

and ye shall be as gods, knowing good and evil. And
when the woman saw that the tree was good for food and
that it was pleasant to the eyes and a tree to be desired to
make one wise, she took of the fruit thereof and did eat,
and gave also unto her husband with her and he did eat.
And the eyes of them both were opened, and they knew
that they were naked ; and they heard the voice of the
Lord God walking in the garden in the cool of the day,
and Adam and his wife hid themselves from the presence
of the Lord God amongst the trees of the garden.
AND THE LORD GOD called unto Adam and
said unto him : Where art thou ? and he said : I heard
thy voice in the garden, and I was afraid, because I was
naked, and I hid myself. And he said : Who told thee
that thou wast naked ? hast thou eaten of the tree whereof
I commanded thee that thou shouldst not eat ?

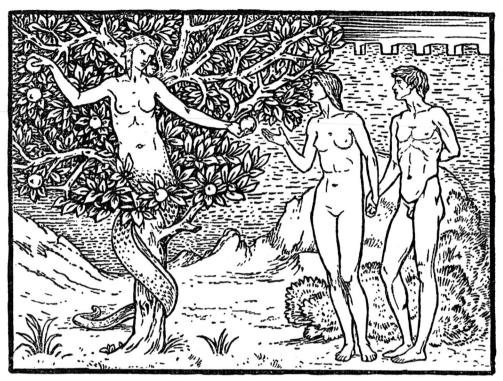

AND THE MAN SAID: The woman whom thou gavest to be with me, she gave me of the tree and I did eat. And the Lord God said unto the woman: What is this that thou hast done? and the woman said: The serpent beguiled me and I did eat. And the Lord God said unto the serpent: Because thou hast done this, thou art cursed above all cattle and above every beast of the field; upon thy belly shalt thou go and dust shalt thou eat all the days of thy life; and I will put enmity between thee and the woman and between thy seed and her seed; it shall bruise thy head, and thou shalt bruise his heel. Unto the woman he said: I will greatly multiply thy sorrow and thy conception; in sorrow thou shalt bring forth children, and thy desire shall be to thy husband, and he shall rule over thee. And unto Adam he said: Because thou hast hearkened unto the voice of thy wife, and hast eaten of the

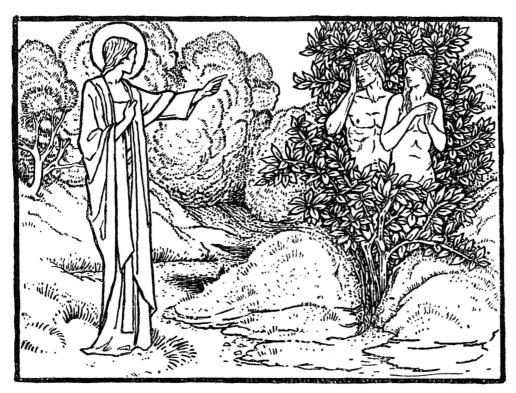

tree of which I commanded thee, saying: Thou shalt not
eat of it: cursed is the ground for thy sake; in sorrow
shalt thou eat of it all the days of thy life, thorns also and
thistles shall it bring forth to thee, and thou shalt eat the
herb of the field. In the sweat of thy face shalt thou eat
bread till thou return unto the ground, for out of it wast
thou taken; for dust thou art, and unto dust shalt thou
return.

AND THE LORD GOD SAID: Behold, the man
is become as one of us, to know good and evil; and now,
lest he put forth his hand and take also of the Tree of Life,
and eat, and live for ever: therefore the Lord God sent
him forth from the garden of Eden to till the ground from
whence he was taken.

SO HE DROVE OUT THE MAN; and he placed
at the east of the garden of Eden Cherubims and a

19

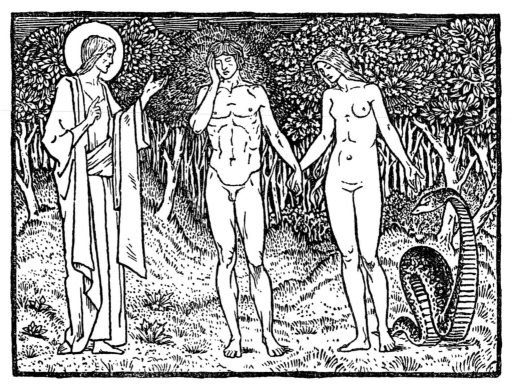

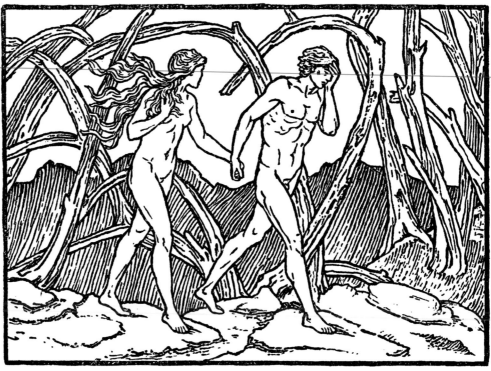

20

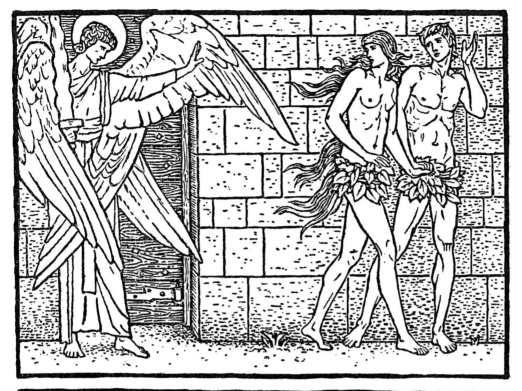

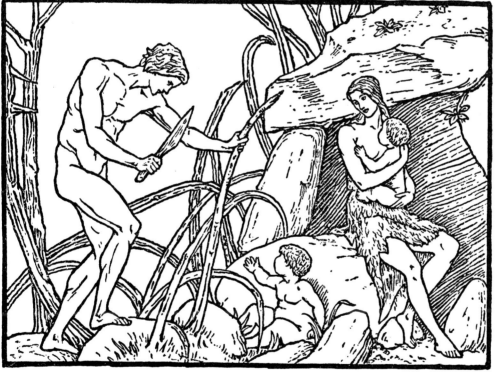

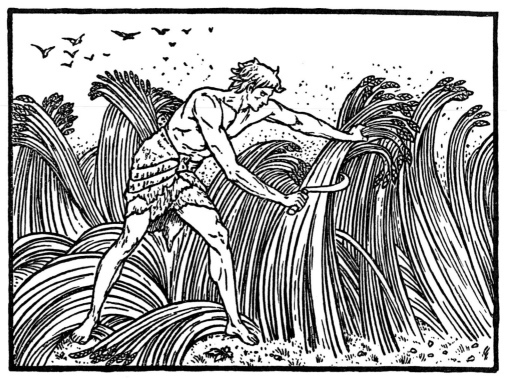

flaming sword which turned every way, to keep the way of the Tree of Life.

AND ADAM knew Eve his wife, and she conceived and bare Cain, and said: I have gotten a man from the Lord. And she again bare his brother Abel. And Abel was a keeper of sheep, but Cain was a tiller of the ground.

AND IN PROCESS OF TIME it came to pass that Cain brought of the fruit of the ground an offering unto the Lord; and Abel, he also brought of the firstlings of his flock and of the fat thereof; and the Lord had respect unto Abel and to his offering, but unto Cain and to his offering he had not respect; and Cain was very wroth, and his countenance fell. And Cain talked with Abel his brother; and it came to pass when they were in the field, that Cain rose up against Abel his brother, and slew him.

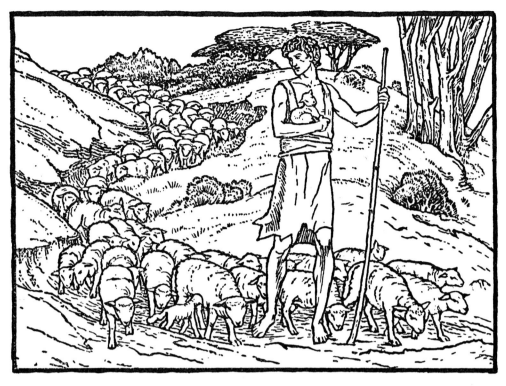

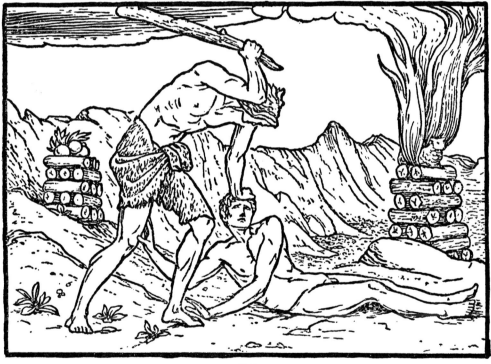

23

The Beginning of the World
was first published in 1902
by Longmans Green and Co.

This facsimile edition was
first published in 2012 by
Pallas Athene (Publishers) Ltd,
Studio 11A, Archway Studios,
25-27 Bickerton Road,
London N19 5JT

Reprinted 2018

www.pallasathene.co.uk

@Pallasathenebooks

@Pallas_Books

@Pallasathenebooks

@Pallasathene0

ISBN 978 1 84368 088 8

Printed in England